DRAW
LIKE THIS!

DRAW LIKE THIS!

HOW ANYONE CAN SEE THE WORLD LIKE AN ARTIST—AND CAPTURE IT ON PAPER

Christopher Locke

A TARCHERPERIGEE BOOK

tarcherperigee

An imprint of Penguin Random House LLC
375 Hudson Street
New York, New York 10014

Most TarcherPerigee books are available at special quantity discounts for bulk purchase for sales promotions, premiums, fund-raising, and educational needs. Special books or book excerpts also can be created to fit specific needs. For details, write: SpecialMarkets@penguinrandomhouse.com.

LIBRARY OF CONGRESS CATALOGING-IN-PUBLICATION DATA
Names: Locke, Christopher, 1978– author.
Title: Draw like this! : how anyone can see the world like an artist-and capture it on paper / Christopher Locke.
Description: New York, New York : Tarcherperigee, an imprint of Penguin Random House LLC, [2016]
Identifiers: LCCN 2016018396 | ISBN 9780143111702
Subjects: LCSH: Drawing—Technique.
Classification: LCC NC730 .L595 2016 | DDC 741.2—dc23

Printed in the United States of America
1 3 5 7 9 10 8 6 4 2

Book design by Sabrina Bowers

CONTENTS

INTRODUCTION

You've probably never heard of me before, and that's OK with me. One doesn't pursue a career in culinary espionage for the fame. But at the height of my career, I decoded the secret sauce, smuggled the eleven herbs and spices, and sabotaged 56 varieties of ketchup. I was forced into retirement in the wake of the infamous "Where's the beef" scandal, when I actually found the beef.

Since leaving the food spy game, I've found a new calling. Now my full-time job is teaching kids how to draw, and it's almost all the excitement I can handle. Some kids come to my class with more experience than others, and that usually manifests itself in a wide range of skill. While some refer to it as "talent," I try to stay away from that word. Talent implies a natural ability, while skill recognizes hard work. In order to become a skilled artist, one must spend a lot of time making art. There's no substitute for practice.

In middle school, I see the students sort themselves into two groups. One group says, "I can't draw," and they give up. They fulfill their own prophecy when they quit drawing. They assume they were dealt a bad hand at birth, and they avoid drawing at all costs. They don't realize it's the lack of practice that causes the lack of skill. They eventually wear their inability like a badge of honor. You'll hear them laugh and say things like, "I can't even draw a straight line," or sometimes, "I can't even draw stick figures!" Why are they so proud of that?

The second group says, "I like drawing," and they keep going.

This is how they become the "talented" ones. They spend more time drawing, which builds their skill. Their peers compliment their work, which builds their confidence. And they spend more time doing the things they are good at, because it makes them happy. They grow up to be adults who wear whatever they want, sleep late, go to wild parties, and drive classic cars. These are the people who know where to find the best tacos, and they can give you impeccable directions to get there.

The only thing that separates the two groups is motivation. It's not talent, it's skill—and the skill comes from doing something wrong until they start to do it right.

As an art teacher, I have developed, refined, and modified a series of exercises to build drawing ability and confidence. I have tested these activities on hundreds of students over several years to figure out what really works. Then, I put these lessons together for you. We will start out by awakening your creativity, then we'll build your drawing skills. Along the way, you will probably surprise yourself with your own ability. Most of us are far more capable than we realize, and we let our own doubt hold us back.

So try not to get discouraged. Just keep going, building your skill. Know that the more you do it, the better you'll get. Whether you're young and just starting out, or old and trying to get back into it, the process is the same. Start now. Start now. Start now.

BEFORE YOU BEGIN DRAWING, YOU'LL NEED TOOLS.

AS YOU GATHER THESE TOOLS, DRAW THEM BELOW:

SKETCH BOOK

PENCILS

ERASER (OPTIONAL)

PENS

White Pearl

PINK

CRAYOLA

COLORED PENCILS

MARKERS (OPTIONAL)

INKBLOTS

W hen a person with little or no artistic experience is forced to draw, they are often overcome with a wave of negativity. It can manifest in many ways, including artist's block, doubt, self-sabotage, procrastination, vertigo, pity, resignation to defeat, daydreaming, scabies, lack of confidence, or a frequent and sudden urge to use the restroom. These sensations can be so overwhelming that they can stop the creative process before it starts. In order to combat this, you should ease into the drawing process, especially if it's been a long time since you last drew anything.

It's a good idea to start by waking up the creative part of your brain without the pressure of drawing. One way to exercise the creative brain is by making sense from seemingly random stimuli. In the early twentieth century, a Swiss psychoanalyst named Klecks Rorschach began using inkblots to find out how crazy his patients were. He would show them symmetrical blotches of ink on paper and have them describe what they saw. By analyzing their responses, he could determine their level of insanity. Here's a fun fact: Later in his career, he would work as Brad Pitt's body double on the set of the hit movie *Fight Club*.

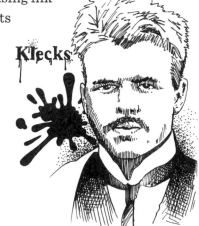

Klecks

PRACTICE

Some inkblots have been provided for you. (They started out as ketchup stains on disposable napkins after a chicken nugget binge, but rendering them in simple lines smells better.) Look at each blot and write down all the things you see. Don't draw anything yet. Just work your imagination and make a list. Don't worry if you think of something completely absurd. In fact, the stranger the better. Let go of your inhibitions, and let the artist come to the surface.

FINAL EXERCISE

After you've made your lists, go back and pick the best entry on each one. Sketch out those things directly on the corresponding blots. Don't worry if the drawing isn't any good. Just put some lines on paper to record your thoughts.

WHAT DOES THIS
MAKE YOU THINK OF?

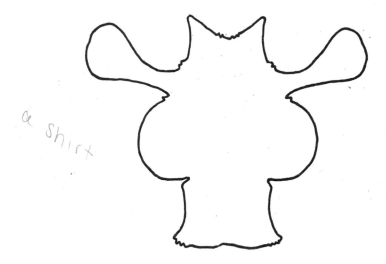

a shirt

WHAT DOES THIS LOOK LIKE?

two
birds

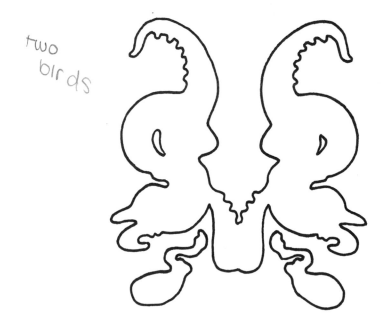

WHAT DO YOU SEE HERE?

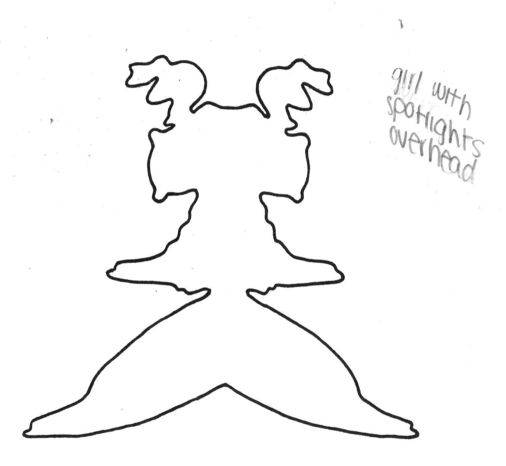

girl with
spotlights
overhead

WHAT IS IT?
octopus

FURTHER PRACTICE

Make up a silly story about the thing you saw in the inkblot. Give it a name, an occupation, and a place to live. Add some conflict to the story, and a possible way to resolve the conflict. Again, embrace your absurdity. This is an exercise in creative thinking, not in superb drawing.

For example, in the first inkblot, I might see a giraffe's head. His name is Kyle the Flying Giraffe, and he can't use a computer. Even if he could put the monitor up high enough that he could see it, and the keyboard down where he could reach it, his hooves lack the precision necessary for typing. Kyle enlists the help of his vegetarian spider friend, who is a proficient typist, thanks to his many legs. The spider really likes apples, but is afraid of heights, so he types for Kyle, and Kyle flies to the top of the tree to pull down an apple in return.

Now, it's your turn.

WRITE A STORY ABOUT SOMETHING
YOU SAW IN AN INK BLOT:

EXTRA CREDIT

Illustrate a scene from your story. See my example of Kyle the Flying
Giraffe. Don't draw a flying giraffe.

ILLUSTRATE A SCENE FROM YOUR STORY

SYMBOLISM

Right now, somewhere in the world, a child is probably drawing a stick man. He lives in a two-dimensional world, standing on a line of green grass, between a lollipop tree and a house made from a triangle on top of a square. The big yellow sun takes up a corner at the top of the page, and shoots yellow needles at stick man's house. In return, the house's square chimney casts out a curly ribbon of smoke, which causes the weird V-birds to fly off into the cottony clouds.

This is not what the world actually looks like. It's a series of symbols children use to represent the things they don't know how to draw. We all do it from time to time. You know what a happy face looks like, but it looks nothing like an actual smiling face.

Symbolism can be useful in a lot of situations. You don't have to completely abandon it. You just need to recognize the difference between a drawing of a house and a drawing of a symbol of a house, and start to think about drawing what you actually see.

Go outside and look at a tree. Does it look like a lollipop? Hopefully not. Look at a house. See if you can tell the difference between a child's drawing of a house and an actual house. Notice that the sun is possibly in view, but you probably don't see lines radiating down from it. If this makes you smile, think about what your face really looks like, as opposed to a smiley face.

FINAL EXERCISE

Spend sixty seconds looking directly at each of the following: house, tree, person, bird, cloud. After you observe each thing, spend sixty seconds sketching each one.

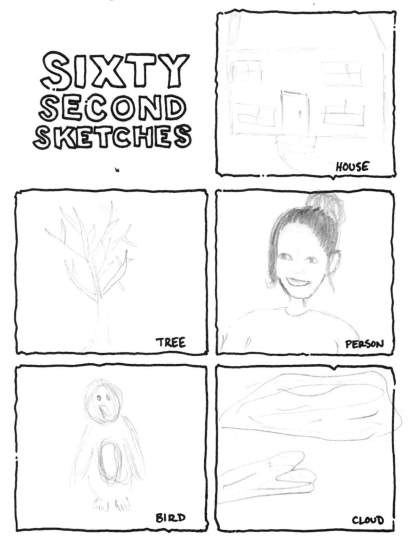

FURTHER PRACTICE

Choose one of your previous sixty-second sketches and expand on it.
Draw it larger and with more detail. Add a background. Or combine
all five items into one drawing.

EXPAND your 60-SECOND sketch HERE

EXTRA CREDIT

Draw a thousand happy faces. It might make you so tired of them that you swear them off forever.

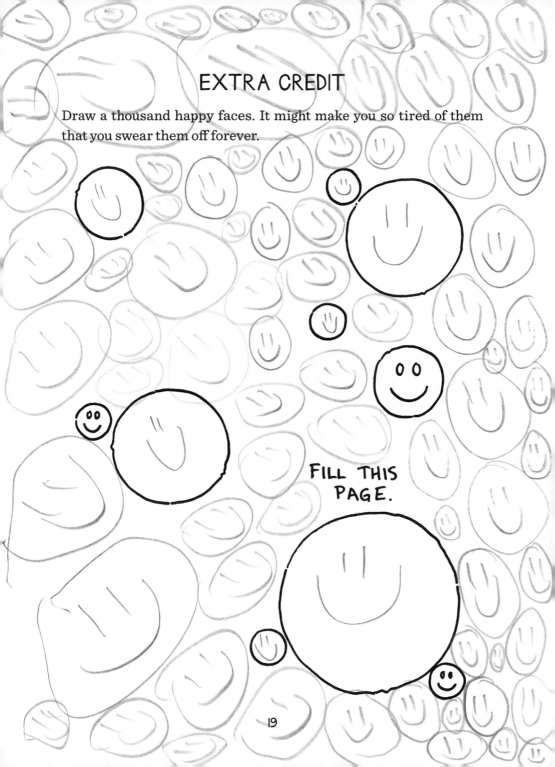

FILL THIS PAGE.

GRID DRAWING

Grid drawing is fun and easy, and a great way to practice your drawing skills. Start with a picture you want to copy. Draw a grid over the picture. Then draw a similar grid on a new piece of paper, and copy the drawing, one square at a time.

Breaking a picture up into smaller squares will help you in three ways. First, you can work on one small part of the picture at a time and forget about the rest, which makes it seem a lot easier. That means you can get a lot further into a drawing before you get bored or frustrated. Second, the grid will make sure everything is right where it's supposed to be, and your drawing will actually look like your best friend instead of a short stack of pancakes. Third, it makes it easy to change the size just by making the second grid bigger or smaller. You can turn a small poodle doodle into a glorious mural on the side of your neighbor's shed, and it will look totally professional!

Grid drawing will help you slow down and look at details, and it will make you more confident as you realize just how easy it can be to draw complex pictures. When I first learned about grid drawing, it was all I wanted to do. I carried a pad of graph paper everywhere I went and drew pictures while I ate dinner. My mom wasn't so happy when I realized the kitchen floor tiles made a fantastic grid. We almost didn't get the security deposit back.

PRACTICE

Look at the three small pictures on the next page. Copy them into the empty squares. They start off easy enough, but the last one might make you cry. Don't worry. It's really not that bad.

While you copy the three images, be aware of the placement of each shape within the box. Does it touch a side? Where along the side does it touch? In the middle? Close to a corner? In which direction does the line go? Is it long or short? Is it straight, or does it curve? How does the black shape interact with the gray shape? A lot of the drawing process is just asking yourself these questions over and over.

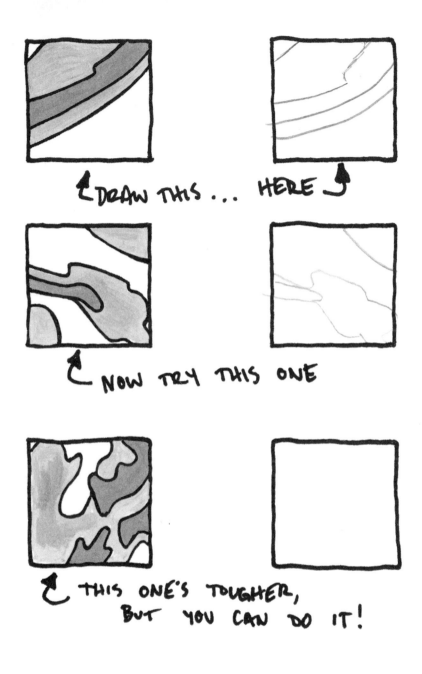

DRAW THIS ... HERE

NOW TRY THIS ONE

THIS ONE'S TOUGHER, BUT YOU CAN DO IT!

FINAL EXERCISE

Look at the next page. Pick any square from the original image and copy it in the blank grid, in the corresponding blank square. When you're done, step back and admire your drawing.

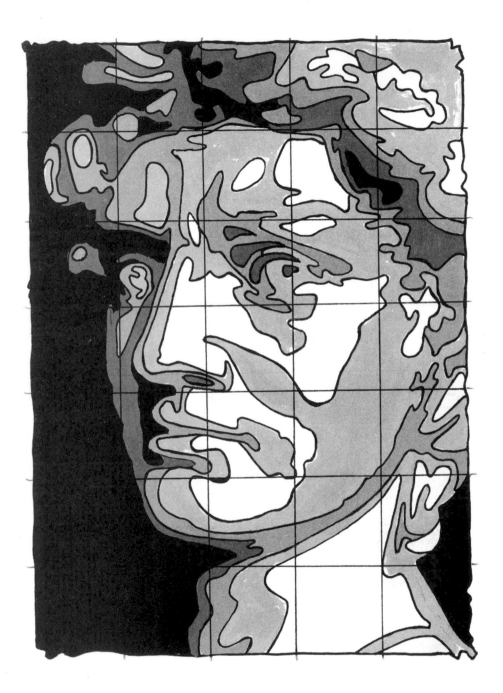

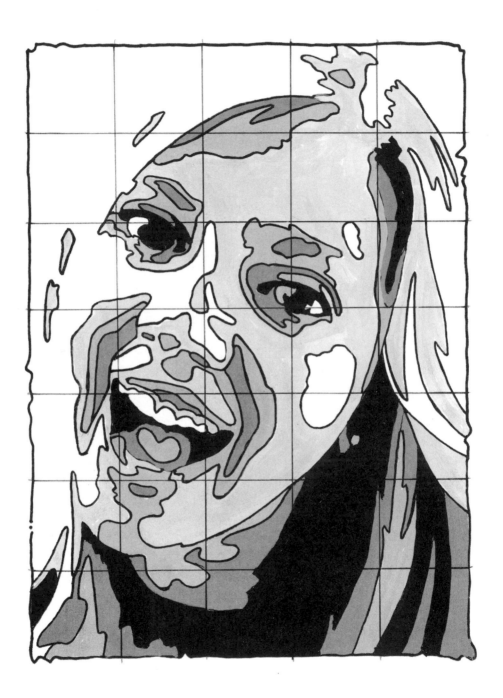

FURTHER PRACTICE

Try drawing a grid over a found image, like a picture from a magazine or newspaper. Make the new grid larger or smaller. Try this with a color image. Graph paper is very helpful for practice.

EXTRA CREDIT

Put a grid over a photo of yourself. Paint a self-portrait on your bathroom door.

LINE

elements OF DESIGN

TEXTURE

SHAPE

VALUE

FORM

SPACE

COLOR

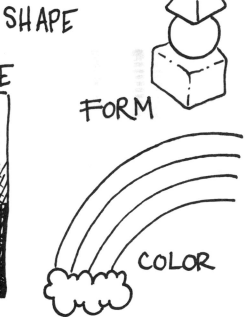

VALUE

I t's a shady world out there. Shadows are all around us, and properly rendering them will help give a flat drawing more depth and realism. Shading turns a circle into a sphere and a triangle into a cone. Value turns a drab day at the beach into a day of blinding sunlight, and a daylight stroll down the street into a midnight creep down an alley. Dramatic shadows make your image more visible from a greater distance and give the viewer more to look at. You can also use shading to separate different parts of the image, pushing the background farther back and bringing important objects to the front.

VALUE SCALE

PRACTICE

A "value scale" is just a strip of shading that helps you practice a full range of darkness. At one end,

the scale is white, just blank paper. The other end is black, as dark as you can get it. In between, every shade of gray should be represented. When you draw, you should try to include that full range in your image. The most common mistake I see in beginning artists is fear of blackness. It's easy to leave out the black and even the dark gray, and fill the page with medium and light values. Your drawings will look much better if you include dark gray and black. Just don't overdo it.

FURTHER PRACTICE

One way to check your range of value is by stepping back from your drawing. Prop the paper up on one side of the room and walk away from it. When you see your drawing from twenty feet away, can you tell what it is? Does the whole page become medium gray? If so, you need more contrast. When you put very light areas right next to dark areas, the lights seem lighter and the darks seem darker. Try adding more intense darkness to a boring drawing and see what happens.

If you are using a pencil, you can vary the pressure as you draw, which will give a range of light and dark. Using a pencil with a soft lead (like a 4B, 6B, or ebony pencil) will help you get your dark areas much darker. But you don't necessarily need to spend a lot of money on a fancy set of pencils. Just get one good dark pencil and see how much range you can create.

If you are using a pen, there are a few techniques we will cover in the next several pages.

CROSSHATCHING
USES OVERLAPPING
PARALLEL LINES.
IT'S CONTROLLED
AND ORDERLY.

STIPPLING
USES LOTS
OF DOTS.
IT'S SOFT AND
SMOOTH.

SCRIBBLING
USES WILD AND
LOOSE LINES.
IT'S CHAOTIC
AND CRUNCHY.

ALL ONE DIRECTION

TWO OVERLAPPING DIRECTIONS

DARK ——————→ LIGHT

LIGHT

DARK

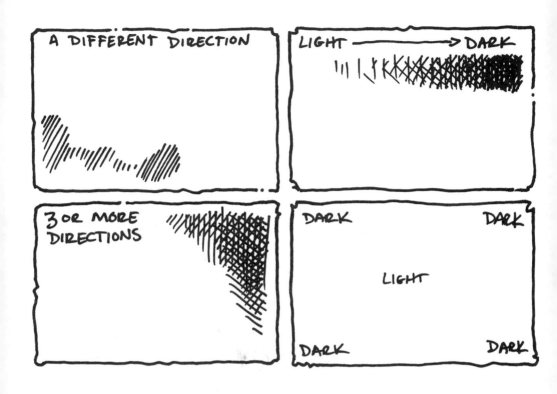

FINAL EXERCISE

Fill in the values in the image on the next page. When you are done, you'll have a finished drawing. This demonstrates that even something as complex as a human face can be reduced to a series of blobs of different values. If you just pay close attention to the shapes of those blobs, and how light or dark they are, you can draw anything.

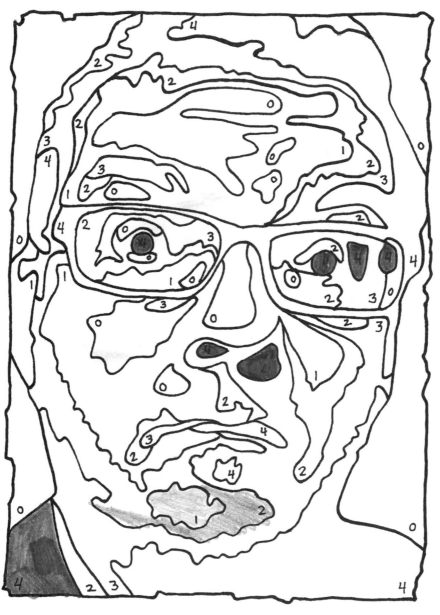

0 = ☐ 1 = ☐ 2 = ☐ 3 = ☐ 4 = ☐

```
4 4 3 4 4 4 3 4 3 4 4 4 4 3 4 2 1 1 1 2 4 3 4 3
4 3 4 3 3 1 1 1 2 2 2 2 2 2 2 1 1   1     1 2 4 3 4
3 4 3 2     1 1 1   1   1   1   1     1 1 1     2 3 4 3
3 3 1     1   1   1   1   1   1   1     1 1 3 2 3
3 2     1 1 1 1 1   1   1 1 1   1   1 1 1 1 1 2 3 3
3 1 1     1   1   1     1   1     1   1 1 1 2 3 4
2 1 1 1 1 1   1 1   1 1 1   1   1 1 1 1 1 1 2 2 3 3
2 1 1     1   1   1   1   1     1   1 1 1 1 2 3 3
2 1 1   1 1 1   1   1   1 1 1   1 1 1   2 1 2 1 4 3
2 1 1     1   1   1   1   1       1   1   2 1 2 3 4
3 2 1 1     1   1   1   1   1     1   1 1 2 2 2 3 4 3
3 1 1   1 2 2 2 1 1   1     1 2 3 4 3 3 2 3 3 4
3 1     2 3 3 3 4 4 4 2 2 1 2 3 4 4 4 4 4 3 4 3 4 4
4 1   2 4 3 4 3 4 3 3     1 3 4 3 4 3 4 3 4 3 3 3 4
3 1     3 3 4 3 4 3 4 2 1     2 3 4 3 3 3 4 3 4 3 3 3
2 1 1 2 2 1 2 2 2 2 1     1 3 1 1 1 2 2 3 2 3 2 4
3 1     1   1 1 1 1 1     1   1 2 2 1 2 1 2 2 2 2 3 3
3     1     1 1 1       2 2 2 1 1 1 1   2 3 4
2 2     1   1   1   1   1   1 2 3 1 1 1 1   1 2 4 3
3 2 1   1   1     1       3 3 1   1   1 1 3 3 4
1 4 2 1 1 1   1   1   1 2 3 2 1   2 2 3 3 4 4
1 2 4 1 1     2 1   2 2 2 3 3 3 1 1 2 3 3 4 3 4
2 4 3 1 1   2 1   2 3 3 4 3 4 2 3 2 3 3 4 4 4 2
1 1 3 3 2 1 1 1       2 2 3 2 2 1 3 3 3 3 4 3
1 1 2 3 3 2 2 1   1   1   1 2 2 2 2 2 4 3 4 3 3 1
1   2 2 3 1 1 1 1   2 2 2 2 3 3 3 3 3 3 3 4 3 1
1 3 3 2 2 1 3 1 1   1 1 2 2 3 3 4 3 4 3 4 3 3 1
1 2 3 3 2 2 1 1 2 3 2 3 3 3 3 3 2 3 3 4 3 4 3 1
1 1 1 3 3 3 3 4 2 2 2 3 3 3 3 3 3 4 3 4 4 4 3 3
1 1 2 3 4 3 4 3 2 1 2 2 3 3 4 3 4 3 4 3 4 1
1 1 2 3 4 3 4 3 4 3 3 3 4 3 4 4 4 4 4 4 3 1
1 1 1 3 3 4 3 4 3 3 3 3 3 4 3 4 4 4 3 4 3 2
1 1   3 4 3 4 4 4 3 4 3 4 4 4 4 4 4 4 3 2 2 1
1   1 1 3 4 3 4 3 4 3 4 3 4 4 4 4 4 3 1   3 1
1   1     3 3 4 4 4 4 4 4 4 4 4 4 4 3 1   1 4 3
```

FURTHER PRACTICE

On heavy card stock, make a handful of small squares of differing values, and cut them out. Now you have a set of value cards. Match those values up with things in the real world. Hold a square up to the wall nearest your desk. Is the wall white, or not quite? What about the desk itself? Your shirt? Look around you. What's the darkest thing you can find in the room? Is it black, or just dark? Use these squares to study and categorize the range of value in the room and to help train your eyes to recognize them.

EXTRA CREDIT

Cut a black-and-white photo from a magazine and paste it onto the next page. Find the darkest part of the image, and draw it on the facing page. Then find the lightest areas of the image and draw them. Pick out each value, one at a time, and copy them carefully until the image is complete.

PASTE A BLACK AND WHITE PHOTO HERE

COPY THE BLACK AND WHITE PHOTO HERE

LINE

Although most people might not notice, the quality of line has a lot of impact on the viewer's perception of a drawing. When lines are drawn effectively, they become part of the image. If you use an inappropriate kind of line, it will distract the viewer and affect the perceived quality of the image. People won't like your drawings and nobody will buy them. You'll be broke and alone, and people will laugh at you. Don't let this happen to you.

Instead, you could use the right kinds of lines in your drawings. People will like to look at them, and you will start selling your work. Soon, people will throw money at you everywhere you go. Next thing you know, you'll be on a beach building a sand castle with the world's most famous foot model. Or at least you won't be the butt of anyone's jokes.

PRACTICE

Lines are a lot like words. They can be bold and strong, or gentle like a whisper. As an artist, one must think about what kind of line is appropriate to describe the subject. Would an artist use the same kind of line to draw both a razor-sharp sword and a wispy cloud? Would the same line that depicts an oozing oil spill be used for the edge of a gravel road? Of course not.

Look at the words on the next page and draw lines that demonstrate those qualities. There is no right or wrong way to draw these lines. It's an exercise in exploration.

THE QUALITY OF YOUR LINE CAN express A RANGE of EMOTION

DRAW THESE LINES

WISPY:

THIN:

THICK:

EXTRA THICK:

DOUBLED:

DOTTED:

CRUNCHY:

WANDERING:

TIMID:

PRICKLY:

BUBBLY:

ELDERLY:

JAGGED:

ANGRY:

STICKY:

FUR:

A SWORD:

DIRT:

FIRE:

OIL:

A SECRET:

FINAL EXERCISE

On the next pages, use varying line qualities to complete the characters, as directed.

FURTHER PRACTICE

Try drawing a portrait of an old lady using bubble-gum lines, then squeaky lines, then crunchy lines. Which one do you like best? Why?

BUBBLE GUM

SQUEAKY

CRUNCHY

EXTRA CREDIT

Try asking a swimsuit model out on a date. If it doesn't work, you haven't earned extra credit. Keep practicing your line work, and you'll get there. It may help if you draw a picture of the model, and don't use tree-bark lines. That's just weird.

SHAPE

Shapes make up everything around us and will make up everything in your drawings. For example, as your drawing skills progress, you will draw portraits without outlining the various features. Instead, you will only use the shapes of the different shadows and highlights on the face. After all, a nose doesn't actually have an outline, but it does cast a shadow. By observing the shape of that shadow and accurately reproducing it, the face begins to appear on the page.

It's not just noses and shadows. Everything around us is made out of (and can be drawn as) shapes. The buildings and everything in them, the forests around the buildings, the creatures between the trees, and the planet we live on, all can be depicted as shapes.

But the shapes are all so different! It's important to explore the range of shapes and keep that range in mind as you compose your drawings.

PRACTICE

A shape is basically the area enclosed by a line that starts and stops at the same point. Shapes can be divided into two basic categories: geometric and organic.

Geometric shapes are mathematically generated, man-made, regular, predictable, and easy to describe over the phone. They are things like squares, triangles, five-pointed stars, and rectangles. Geometric shapes are good for windows and doors, skyscrapers, modern furniture, electronics, robots, rockets, and the flat spot on top of your best friend's head. They make your drawings feel orderly and precise, which is calming to the viewer.

Organic shapes are a little more loose. They are shapes formed in nature, or irregular shapes that don't have a simple mathematical formula. Organic shapes are things like puddles, strawberries, pit stains, wrinkles, and ears. They make your draw-ings feel more natural and free. However, using too many organic shapes can be confusing or unsettling to the viewer.

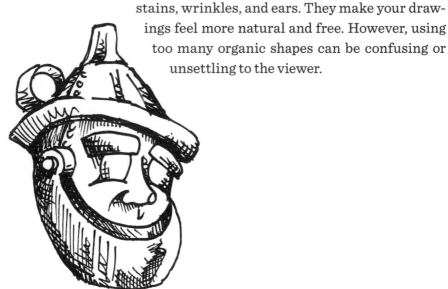

Look at the following examples. Fill the rest of the pages with either geometric or organic shapes. Make some of the shapes overlap and some of them run off the page. You can even color them in.

FILL THESE PAGES WITH GEOMETRIC SHAPES.

GEOMETRIC SHAPES ARE
RIGID AND PREDICTABLE.
THEY GIVE YOUR DRAWINGS
ORDER & STABILITY.

ORGANIC SHAPES
ARE WILD.
THEY MAKE YOUR DRAWINGS
NATURAL, EVEN CHAOTIC.

FILL THESE PAGES WITH ORGANIC SHAPES

FINAL EXERCISE

Take a trip to a zoo, farm, or pet store. Draw a few animals using only geometric shapes. If you do this enough, you might find that it helps you with composition, proportion, and layout.

FURTHER PRACTICE

Imagine a home made up of only organic shapes. Think about how different your home would be if it had no geometric shapes at all. Re-design an everyday object (like a trash can, table, or lamp) with no geometric shapes. Is it an improvement? Why or why not?

EXTRA CREDIT

Look at the world around you, and imagine geometric things being made in organic shapes. What if a fire hydrant looked like a tree stump? Why are doorways rectangular if people are not? Why do we cover our natural world with such rigid geometry?

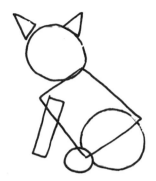

FILL THIS PAGE WITH GEOMETRIC ANIMALS

SPACE

In any drawing composition, there are three main components:

- Positive shapes are the objects that make up the actual content of the drawing.

- Negative space is the area around and between the objects in the drawing.

- Format is the outer boundary of the drawing, or the edge of the paper.

Negative space is a very important part of any drawing and can be manipulated to achieve interesting results. Too much negative space may make the drawing feel empty or make the subject seem less significant, or even weak. For example, if a man is floating on a raft in the middle of a vast ocean, his situation will seem more hopeless than if he's floating in a small lake.

The opposite is also true. A lack of negative space can make a drawing more dynamic, making a subject appear powerful or even threatening. A drawing without negative space can also feel crowded or claustrophobic.

PRACTICE

Look at the drawings on the following pages and try to determine the difference between the positive shapes and negative space. Notice how they interact. It may help to fill in the negative space with a color to make it really stand out. Now copy *only* the negative space into the new format (frame). Do not draw any of the details in the positive shapes.

COPY THE NEGATIVE SPACE AROUND THE DUCK.
DO **NOT** COPY THE DUCK!
(THERE ARE 5 SPACES.)

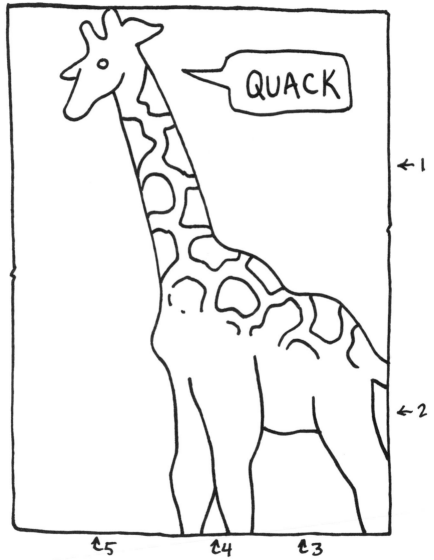

COPY THE NOTHINGNESS
AROUND UNCLE KARL.
DONT FORGET INSIDE HIS HANDLE.
THERE ARE FOUR SECTIONS.

FINAL EXERCISE

Examine the portraits of my cousin Timothy on the next page. How do they make you feel? How do you think Timothy feels? Using the portrait provided, draw a format (frame) that makes him feel normal again. Then, using the format provided, draw a portrait of Timothy, but make him feel lost and hopeless. Don't worry if the drawing doesn't really look like Timothy. The feeling is more important than the details. Think about negative space and how it affects your perception.

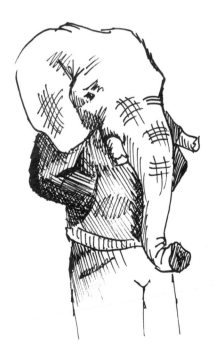

HOW DOES TIMOTHY FEEL?

HOW DOES TIMOTHY FEEL?

MAKE TIMOTHY NORMAL

DRAW TIMOTHY LOST AND HOPELESS

FURTHER PRACTICE

Try cutting photos from magazines and experimenting with differ-ent amounts of negative space to change the mood of the image. Cut out a picture of a happy person and fill the negative space with sad, scary, or angry images. Find some photos of underfed models and remove the positive shapes, so you have a page with only the negative space. Then, cut a more realistic person-shape into the page.

EXTRA CREDIT

Find a picture of your ex and cut them out. Put them in a small format that makes them look overbearing and scary. Then expand the format until there's so much negative space that they look sad and lonely. Don't you feel better?

BELOW: TOULOUSE-LAUTREC'S FAMOUS DRAWING "ZEKE THE HOBOKEN PLUMBER AND HIS HOMELY WIFE GRETCHEN." COPY THE NEGATIVE SPACE ONLY.

CAN YOU IDENTIFY THIS FORMER U.S.
PRESIDENT? NOW DRAW HIM BELOW.

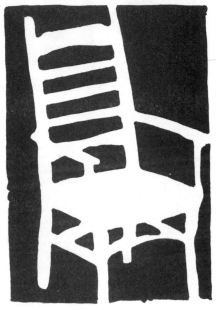

MANIPULATING SPACE

OBJECTS THAT
ARE CLOSER
WILL APPEAR
TO BE LARGER.

OVERLAPPING
SHOWS
DEPTH.

DISTANT OBJECTS
LOSE DETAIL
AND INTENSITY.

CLOSER OBJECTS
OFTEN ARE
LOWER ON
THE PAGE.

COLOR

There's so much to say about color that we can only scratch the surface here.

What we know as "color" or "light" is only a tiny sliver of the radiation that we are bombarded with at all times. We're surrounded by radio waves, gamma rays, ultraviolet light, infrared light, and X-rays. Colors are just the part we can actually see.

On the next page you'll find a classic color wheel, the one that painters use. It's a good place to start.

PRACTICE

Color in the spaces on the color wheel. Start with the "primary" colors, red, yellow, and blue. These colors cannot be made by mixing any other colors. "Secondary" colors can be made by mixing any two primary colors. Red and blue make purple, for example. Color in all the secondary colors. Now, by mixing a secondary color with the neighboring primary color, you get a "tertiary" color, like red-orange.

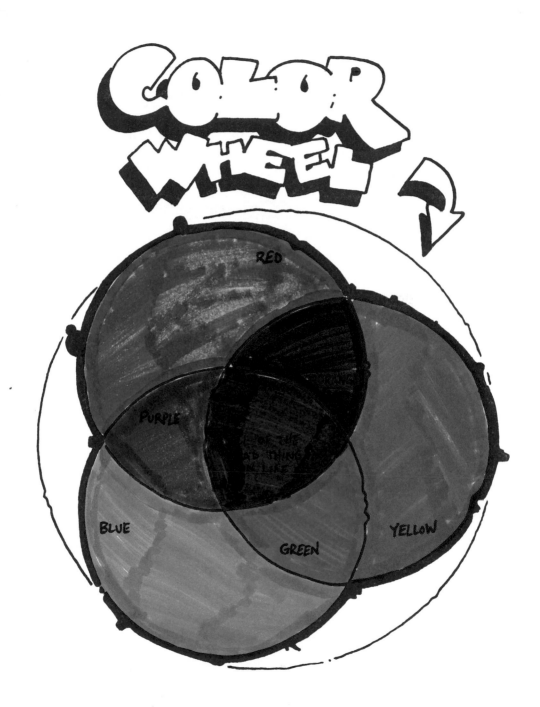

FINAL EXERCISE

Look at the "color schemes" on the pages that follow. Fill in the shapes to illustrate the different schemes. When you are drawing or painting, it's important to think about these color schemes and how they can affect your image. It's easy to connect colors to feelings like hot and cold, but what colors would you use to describe sadness, serenity, or suffering?

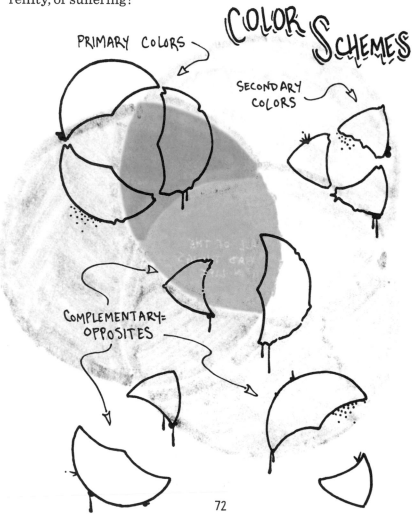

72

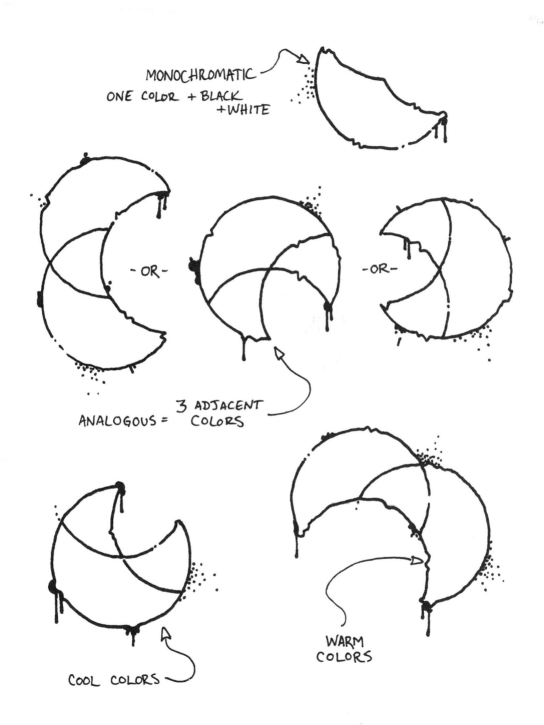

MONOCHROMATIC
ONE COLOR + BLACK
+ WHITE

- OR -

- OR -

ANALOGOUS = 3 ADJACENT
COLORS

COOL COLORS

WARM
COLORS

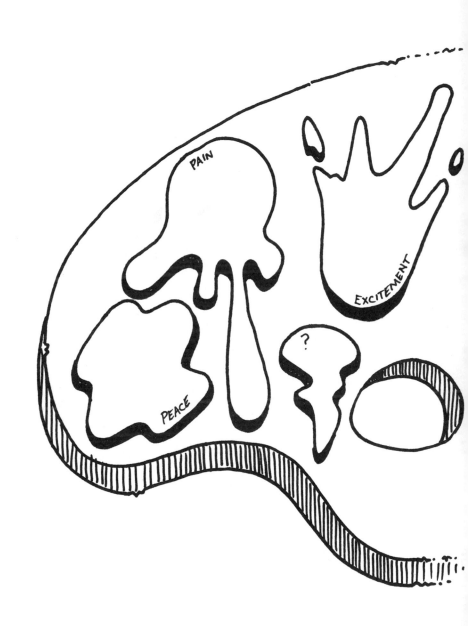

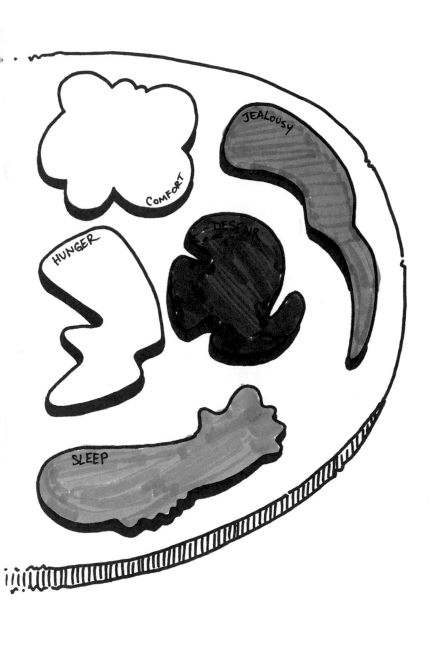

FURTHER PRACTICE

Draw a self-portrait using a monochromatic color scheme. How does it make you feel? Now redraw the same self-portrait using only the complementary color. Does it make you feel the same or different? Why?

Try to assign a color to a sound. What color is a ringing bell? Ripping paper? A baby's cry?

EXTRA CREDIT

Invent a new color wheel using all new colors. Make sure you give them new names. You can base your colors on things you find beautiful, on a range of emotions, or on the things you find stuck to the sole of your shoe. Blend two or more "traditional" colors to make a color you've never seen before. Give it a name. When people ask you for your favorite color, that's the one you should use.

Go to the paint store and pick a few colors from the sample rack. Notice how silly most of the names are. Come up with more honest ones. Perhaps "Honeysuckle" is really the color of "Grandpa's teeth." Rename "Perfectly Peachy" something like "Adhesive Bandage."

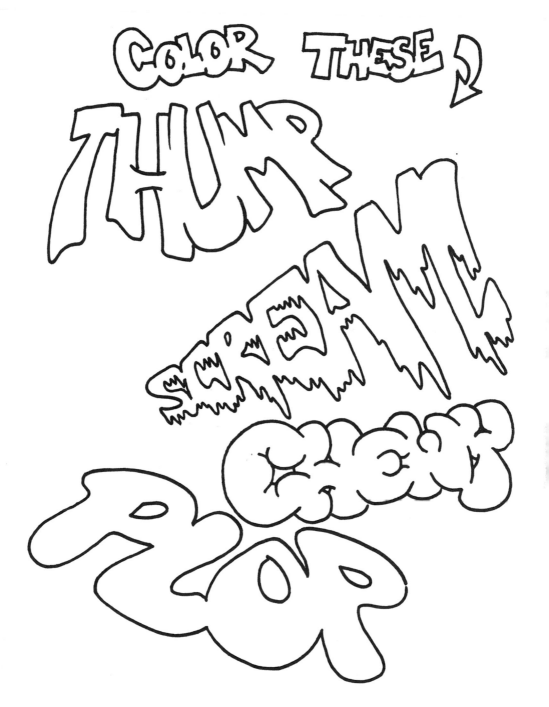

TEXTURE

Imagine what the world would be like if every surface had the same texture. The bathroom floor, the inside of your shoes, the street you live on, and a sandy beach would all feel the same. Nothing would stand out anymore. How boring!

Although we don't live in this boring semismooth world, we often draw as if we do. Most people forget about texture when they draw. Just like with lines, a wide textural vocabulary can elevate your drawings to the next level.

PRACTICE

Spend some time looking around you and imagine what each surface feels like. What does the wall feel like? What's the bumpiest thing in the room? Wood, fabric, carpet, tile, cardboard, brick, and stone all have different surfaces. Even those materials can be finished in varying ways. In my classroom, we found twenty very different textures in just a few minutes.

FINAL EXERCISE

Fill in the spaces on the next page, illustrating a different surface in each section. Some have been started for you.

FURTHER PRACTICE

Look at the drawing of the clown. Notice how line is used to show texture. The bumpy ground and coarse bricks are implied with the quality of lines around them. The clown's nose is smooth, and his chin is rough. His hair and the puddle are drawn with very different lines, because they are very different things.

Now put a piece of tracing paper over the clown and trace the picture, but use the same boring line for every edge. Leave out anything that would indicate texture. Compare the two drawings, and take note of the difference in overall feeling.

EXTRA CREDIT

Buy an orbital sander and load it up with 220-grit sandpaper. Sand everything you own until you can't tell the difference between your bed and a waffle iron. Or just imagine how that would go down.

HANDS

For thousands of years, artists have revered the human body as one of the most beautiful subjects in the world. But when we really think about it, the human body is kind of lumpy and awkward, with lots of things sticking out all over. More than any other body part, hands are complex and hard to draw, with their bony parts and flabby parts, hairs, wrinkles, and nails. There's good news, though. Once you master drawing hands, you will be able to draw pretty much anything. There's nothing in life more intimidating to draw than a hand. Here's how it's done.

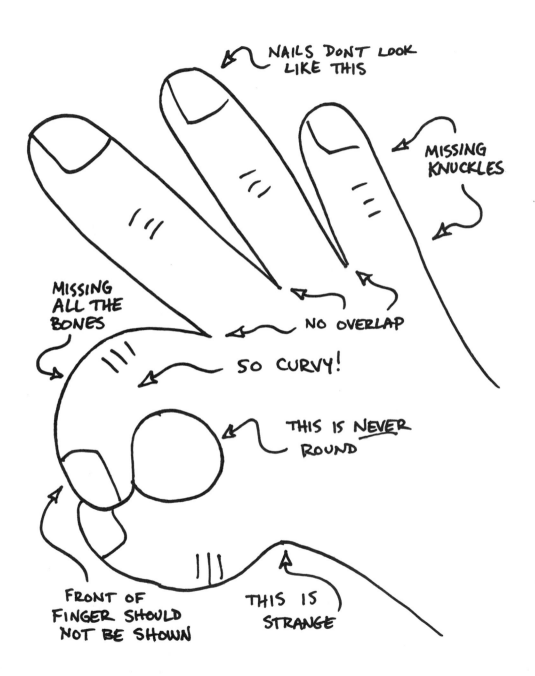

PRACTICE

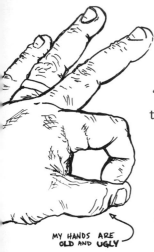

MY HANDS ARE
OLD AND UGLY

"Blind contour" is a very common exercise in drawing tutorials. Basically, a contour line is the line that describes the shape and form of an object. It's more than just an outline because it can show interior details and textures as well, but it may be easiest to think of it as an outline of all the parts and details. The process of drawing a contour line is simple but scary. Use tape or something heavy to stick your drawing to the table so it will not move. Turn your body so you can easily draw on the paper, but cannot easily see it. This will help you resist the urge to peek at the drawing. Grab a pencil and get ready to draw.

Now, hold your other hand in front of you where you can see it. Try to position it in an interesting way. Without looking at the paper, you will draw your hand. Start at the wrist and move your eyes up along the side. As your eyes follow the contours, your other hand should move the pencil in the same direction. When your eyes get to a wrinkle or knuckle, the pencil should follow those same wrinkles. Imagine an ant crawling on your hand and concentrate on just the one place the ant is walking. As the ant goes up the side of your hand, let your pencil follow that contour. Don't worry about the rest of your hand. Just focus on the one spot. As the ant moves, the pencil moves. Go slow. Concentrate. The first time you do this it may take you two minutes to draw two fingers. That's OK. While you are drawing, remember never to lift your pencil from the paper. If you need to go back to another part of the drawing, retrace your line with the pencil as you retrace it with your eyes. Everything should be connected. Create several drawings like this.

If you do it right, your brain will stop telling you what a hand should look like, and you will start drawing exactly what you see.

You may enter a very focused trance and lose track of everything else around you. This is good! The longer you can stay in this zone, the deeper you can concentrate. Don't forget to start a timer so you won't get lost in your drawing forever.

It's important to keep in mind that because you cannot look at the paper, your drawing will be extremely disjointed. Don't be discouraged. It's normal for a blind contour drawing to look like a hairy mess. This exercise is about process, not product. You are working on your brain. The drawing is just a side effect.

After you have completed a few blind contour drawings, you can move on to "modified blind contour." This is similar to what you just did, but you can periodically pause the process and look at the paper to see how you're doing. While you are looking at the paper, you should not be drawing. You are just checking on your progress.

FINAL EXERCISE

Draw your hand. You can look at the paper while you do it. This should be much easier and less scary.

FURTHER PRACTICE

Any time you are bored or don't have anything to draw, draw your hand. It should get a bit easier each time.

EXTRA CREDIT

Use the nondominant hand to draw the dominant hand. It'll do weird things to your brain. Call it "Self-Portrait #61" and sell it for a ton of cash. Buy a jet.

DRAW YOUR RIGHT HAND WITH YOUR LEFT HAND

DRAW YOUR LEFT HAND WITH YOUR RIGHT HAND

DRAW THE SAME HAND USING **VALUE**

DRAW THE SAME **HAND** IN NEGATIVE SPACE ⟳

BREAKFAST
MAN

Some of the earliest cave paintings show humans drawn as stick figures, sometimes called "Stick Man." The arms, legs, torso, and abdomen are all drawn as simple sticks with no dimensional substance. Of course, prehistoric humans didn't really look like sticks. They just drew that way because they hadn't heard of Breakfast Man. He's one step up from Stick Man but not quite a properly drawn human. Breakfast Man is the easiest way to wean yourself from Stick Man and set you on the path to drawing people who look like people. The earliest humans could have saved us all a lot of confusion if they had just bought this book and learned about Breakfast Man.

PRACTICE

Look at Stick Man.

Notice he has no shoulders. How on earth do you expect him to carry a backpack? Where are his lungs? When he eats, where does the food go? Instead of a stick, you should make his torso from a trapezoid, or at the very least, a blob with some thickness. Now, let's look at his arms. Without muscle, he's going to have a hard time picking anything up. And how on earth could he wear a wristwatch? I know what you're thinking . . . "I can't draw *muscular* arms." Here's some

STICKMAN

good news. You don't have to start out with drawing Mister Universe. Just draw Breakfast Man. His bicep can be reasonably represented with a sausage, as can his forearm. For the hand, just draw a biscuit. As you draw the arms, say out loud these words: "Sausage, sausage, biscuit." The elbow exists between the sausages, so the arm can be posed with a semblance of realism. Legs are the same. Sausage, sausage, biscuit. Only the biscuit should look like a shoe. So maybe sausage, sausage, hoagie. And then put some pants on him.

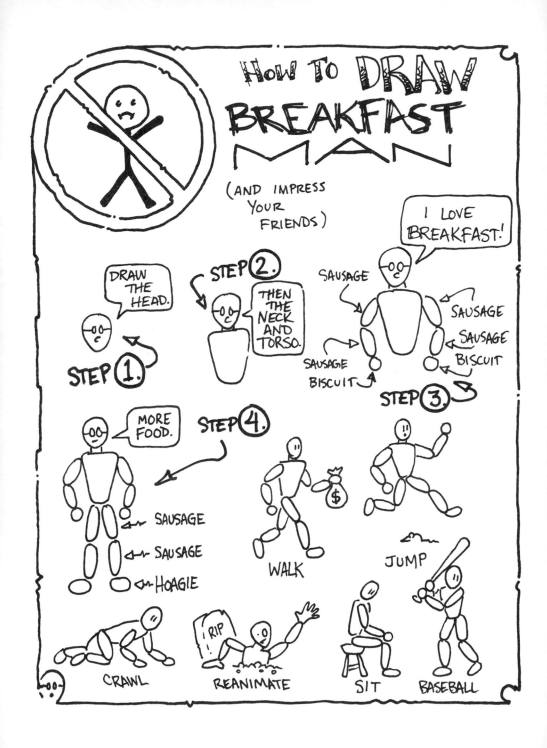

FINAL EXERCISE

Draw a few versions of Breakfast Man in different poses. Use Breakfast Man as a basis for drawing some people you see in real life. It's a quick and easy way to document different poses.

FURTHER PRACTICE

Use Breakfast Man as the basis for inventing new people in new poses. Take note of how much better your drawings look when compared to drawings of Stick Man.

EXTRA CREDIT

Find a cave within walking distance of your house. Sneak in at night and draw an elaborate mural showing a battle between a tribe of Stick Men and a tribe of Breakfast Men. Include some other fun things like pyramids, flying saucers, the Loch Ness monster, and the planet Pluto. Bask in the glory as your "ancient" cave paintings rewrite history.

SKELETAL
STRUCTURE

Most kids love those books that show the steps for drawing twenty sea creatures, or fifty dogs, or five hundred different hummingbirds. The problem with these books is that they only show how to copy the specific steps to redraw the same image over and over. You probably don't want to know how to draw the exact same hammerhead shark that's on the cover of the book. You want to know how to draw whatever you want.

Pretty much any animal that has a spine also has a lot of other common features, thanks to evolution. Did you know blue whale skeletons have remnants of a pelvis and legs? Did you know bat wings are actually huge webbed hands? Understanding the basic skeletal structure will allow you much more freedom to draw animals, instead of restricting you to drawing a step-by-step Chihuahua for the rest of your life.

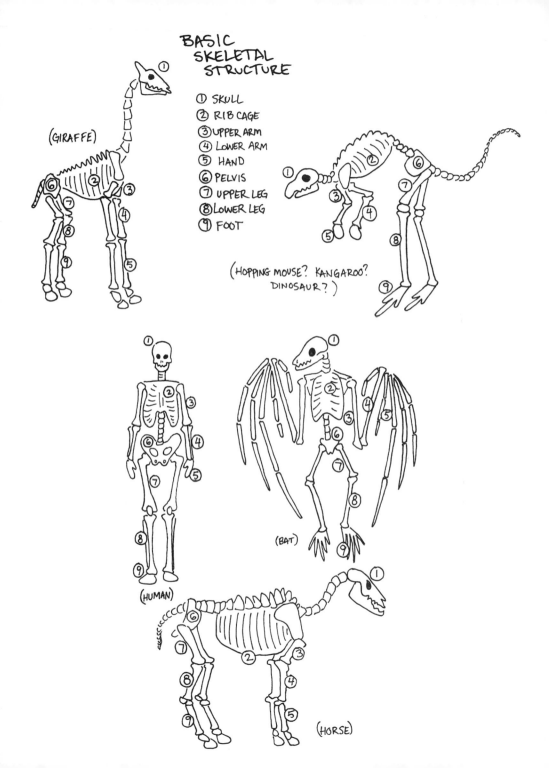

BASIC
SKELETAL
STRUCTURE

① SKULL
② RIB CAGE
③ UPPER ARM
④ LOWER ARM
⑤ HAND
⑥ PELVIS
⑦ UPPER LEG
⑧ LOWER LEG
⑨ FOOT

(GIRAFFE)

(HOPPING MOUSE? KANGAROO?
DINOSAUR?)

(HUMAN)

(BAT)

(HORSE)

PRACTICE

Invent a new creature. Think about what environment it would inhabit and what features would help it survive. Start with the spine and skull, keeping in mind that the length and thickness of both may change, depending on the creature's lifestyle. Size of the eyes may vary if the animal is nocturnal or if it lives in the desert. Size of the mouth might change depending on what the creature eats. Think about the animal's tail and how it might use it, or even if it needs one at all. Add a pelvis and shoulder blades. When you draw in the rib cage, leave an opening for pregnancy (if it's a mammal). Does the beast have long legs for running fast, or is it a stubby little tunnel dweller? Once you get the whole skeleton posed and proportioned, you can add muscle, skin, scales, fur, flippers, horns, ears, claws, hooves, or spikes.

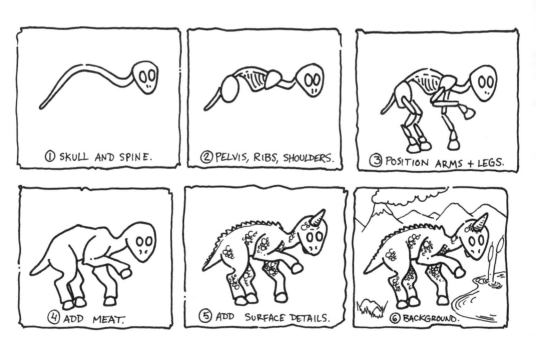

PRACTICE

SKELETONS

HERE

FINAL EXERCISE

Draw an animal that would live at the top of the food chain. Consider all the ways it would have to adapt in order to survive. Now invent a new creature that would destroy it. Draw the two engaged in a fight to the death. Include a background. Once you can do this, it should be no problem for you to draw a sleeping cat.

FURTHER PRACTICE

Consider a mundane environment (public library, litter box, desert, school cafeteria, a car's trunk) and invent a new animal to inhabit it. Then figure out where the creature would go if it outgrew its home.

EXTRA CREDIT

Draw a hammerhead shark. Draw a Chihuahua. Draw a hamster riding on the back of a cat. Find one of those "draw fifty dogs" books and follow the steps out of order. Or follow the first half of the steps, then see if you can change the drawing to an octopus or gnu. Combine two very different animals into one drawing, like an alligator and a zebra. Draw a $25,000 alpaca.

PROPORTIONS OF THE HUMAN BODY

Every drawing student suffers through it at least once. It's the dried-up old lesson about the proper proportions of the human body. Of course, it's important to have a basic understanding of the layout and main components, in case you want to draw a person without a model. But it's always better to have reference—either an actual person, a photo of a person, or at the very least one of those awful wooden blobby mannequins from the craft store.

Many people agree that the adult male human is seven and a half heads tall, though others believe it's eight, and some characters are drawn as many as nine heads tall. What about people who are shaped like a fire hydrant (like me)? The truth is, there's no single formula when it comes to proportion. Instead of working to make everyone fit the mold, just draw the person's body as you see it. If you are drawing a perfectly proportioned athletic male who is standing upright and facing you, the standard rules might help you. But then you will have an extremely boring drawing.

PRACTICE

Look at the diagram. Notice as you go from the top to the bottom that each head unit lands on a specific landmark. If you want to reproduce this kind of drawing, you can memorize these landmarks. Neck, Nipples, Navel, No-no zone, kNuckles, kNeecaps, New shoes. Don't spend too much time on this diagram, though. Nobody really cares if your people are seven heads tall or nine. Just try not to make them look like mutants.

Now, draw a couple of people using the NNNN-nzkNkNNs method. Try dressing them up in different outfits; make them an investment banker, lawyer, stockbroker, corporate spokesperson, or pallbearer. Wow! How exciting!

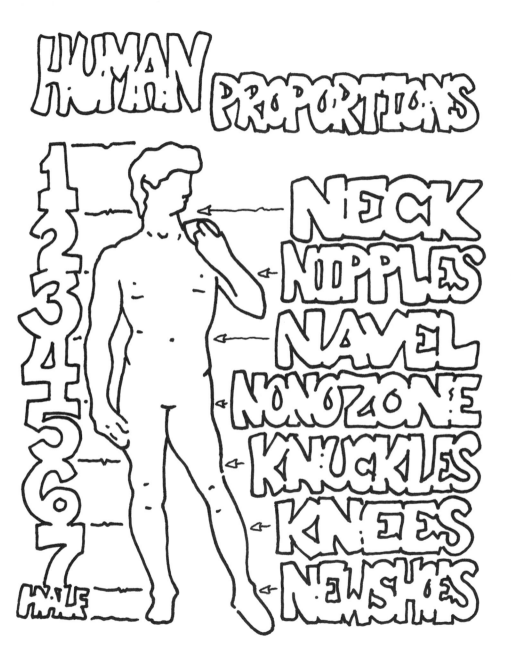

PRACTICE
DRAWING
PEOPLE

(PROPERLY
PROPORTIONED,
PLEASE!)

FINAL EXERCISE

Draw a standard seven-and-a-half-head person. Don't forget NNNN-nzkNkNNs. Turn that person into a self-portrait. Does it look right to you? Why or why not? Is it a da Vinci or a DeVito? Now throw that drawing away, and don't ever draw a perfectly proportioned, straight-standing, boring, oversimplified figure ever again.

FURTHER PRACTICE

Try drawing a range of body types and analyze their proportions. Look at the location of the waistband on different people, and take note of how that alters our perception. Old people, clowns, and nerds all wear their pants really high, which makes them look like they have long legs. A lot of women's fashions have high waistbands. Why would women want to look like nerdy old clowns? Now draw someone who is only four heads tall, and someone who is ten heads tall. Try cutting out pictures of celebrities from magazines and putting them on disproportionate bodies.

EXTRA CREDIT

Go to your local gym. Examine some of the more athletic individuals and their proportions. When you've figured out what makes them look a bit freakish, be sure not to tell them.

PROPORTIONS OF THE HUMAN FACE

As with the proportions of the human body, a lot of drawing instruction revolves around memorizing a system of measurements for laying out the components of the human face. While it is important to understand that such a formula exists, it should not be a crutch used to support every drawing you do that includes someone's face.

Assume the subject is facing the artist in a completely straight-on clinical pose. If the face is an inverted egg shape, the eyes will actually fall about halfway from the top to the bottom. This may seem strange if you've never really looked, because most people don't realize how big foreheads are. Close examination should prove to you that the eyes really do appear halfway between the chin and top of the head, and the hairline sometimes falls halfway from the top of the head to the eyes. Halfway down from the eyes to the chin, you'll find the underside of the nose. Halfway from there to the chin, you should find the lowest part of the lower lip.

The head is usually five eyes wide, with one eye width between the eyes, and one eye width between the outer corner of each eye and the side of the head. Pupils line up with the corners of the mouth, and

the ears line up with some other stuff. Does anyone actually draw like this? I don't. It's probably best for you to know that these basic guidelines exist, and then don't worry so much about them. Just draw what you see. Most of the time, your subject won't be facing you in a way that makes all these guidelines applicable.

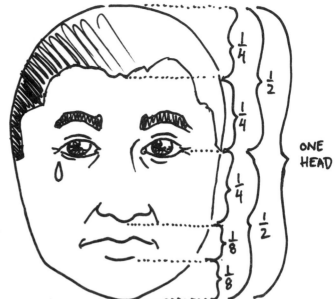

Somewhat useful, slightly arbitrary, totally overrated proportions of the human head, for use with straight-on, expressionless documentation of boring people's faces

ONE HEAD

PRACTICE

Draw a properly proportioned face. Start with the overall shape of the head. Draw a line at the middle for the eyes, then divide the top in half for the hairline, and the bottom in half for the nose. Divide the lowest section in half for the bottom of the lower lip. Along the eye line, divide the width by five. Draw eyes in the even-numbered spaces. Now draw in the component parts and erase your guidelines. Add more details like hairs, wrinkles, freckles, scars, scratches, bite marks, open wounds, microchips, dandelions, and ants. You might as well make this drawing silly, because in the real world, people aren't going to be perfectly proportioned, and you probably won't draw them from such a boring angle. This method of drawing faces will definitely come in handy if you become a police sketch artist or an autopsy illustrator.

DO IT.

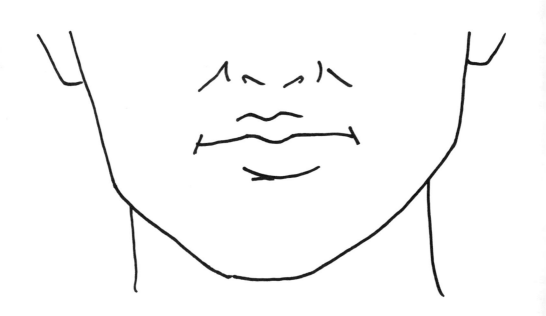

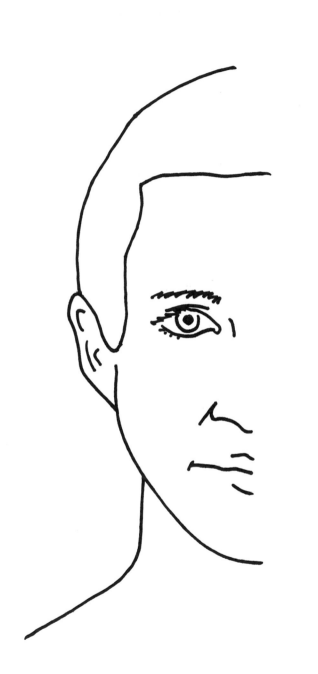

FINAL EXERCISE

Find a large photo of a model's face in a fashion magazine. Makeup advertisements are really good for this. Cut out all the components and arrange them so they fit this "ideal" set of proportions. Now, scrunch them up into a tiny face and draw it. Stretch them out into a huge face and draw it. Try putting the nose really high between the eyes, and the mouth really low. Or put the eyes too close together or way too far apart. Draw those, too.

FURTHER PRACTICE

Rearrange the proportions on one celebrity's photo to make him or her look like another celebrity. I don't want to name names, but some famous faces have . . . interesting proportions.

EXTRA CREDIT

Plastic surgery is always an option.

PORTRAITS

Drawing a recognizable portrait is one of the most intimidating (and at the same time rewarding) things you will ever do. Even the most seasoned artists can experience elevated levels of anxiety when it's time to draw a face. One of the ways to combat that anxiety is to stop thinking of the subject as a face and break it down into its smaller components. When it becomes a collection of lines and shapes and shadows, it stops being so scary. If you can draw a hand that looks like a hand or a house that looks like a house, you should be able to draw a face that looks like a face. Don't be scared.

PRACTICE

One of the many strange things happening on the Internet lately involves pretty girls making ugly faces. I find ugly faces to be much less intimidating to draw, because even if I do it right, the drawing is still ugly. You may also find that ugly faces are easier to draw, so I suggest you start there. Do a series of four-minute blind contour drawings of silly or ugly faces.

You should do these drawings in blind contour like you did the hand drawings, because it will help you break down those mental barriers. Tape a piece of paper down, and keep your eyes on the photo you're emulating. Imagine an ant crawling along the face, and trace its path. Go slow. Take your time. Note every detail with the pencil

as you see it with your eyes. When you are done with the drawing, look at it and laugh. Remember, it's supposed to be ugly.

Move on to four-minute modified blind contour drawings of celebrity mug shots, this time pausing to look at your paper every once in a while. Finally, when you are ready, try a regular drawing of a B-list celebrity. You should draw people that are vaguely (but not completely) familiar, which makes it more difficult for your friends to recognize inaccuracies in your drawing.

STOP
LOOKING AT EYES NOSE MOUTH AND START SEEING ORGANIC SHAPES, BLOBS FILLED WITH VALUE, AND HOW THEY RELATE.

YOUR DRAWINGS WILL THANK YOU.

FINAL EXERCISE

A portrait is just a collection of shapes and lines of different values.
Copy the shapes and values into the spaces that follow. The shapes
will get progressively more complex, but there will still be only five
values. It's important to keep in mind that you are not drawing eyes,
nose, or mouth, but simply copying gray blobs.

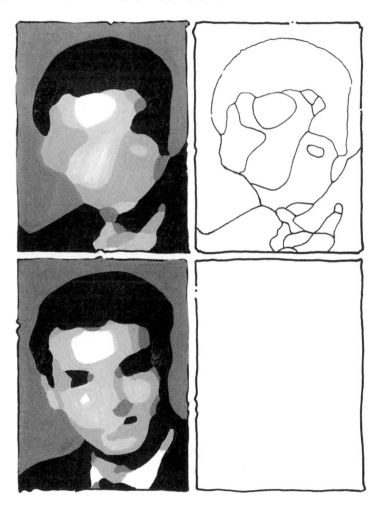

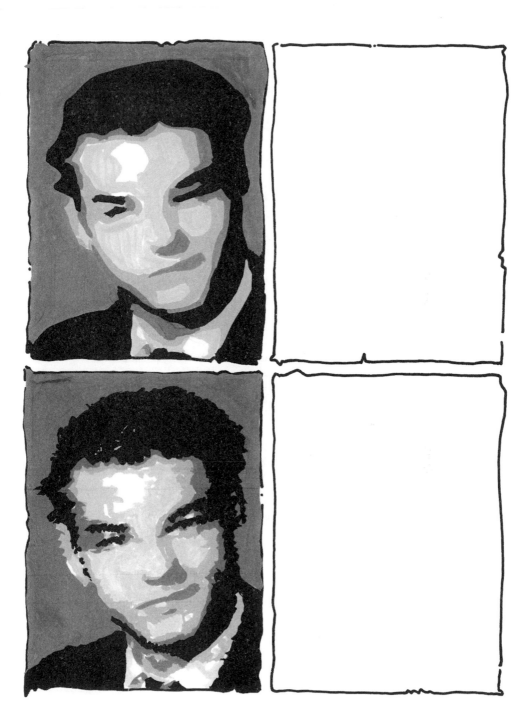

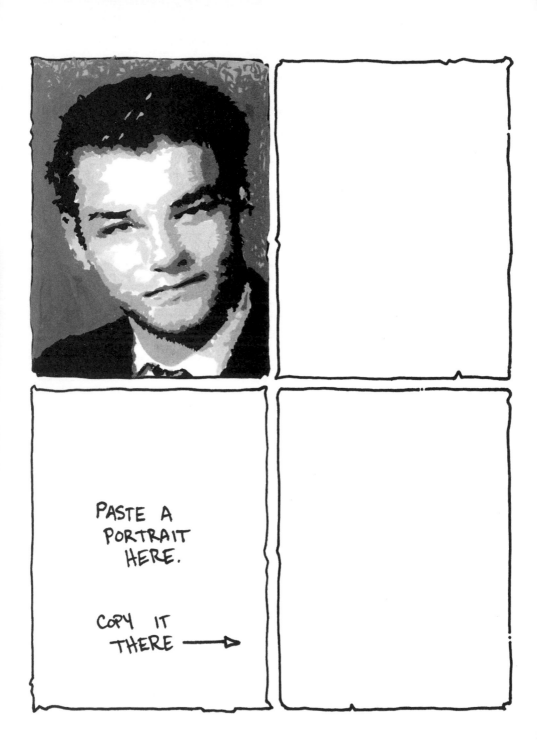

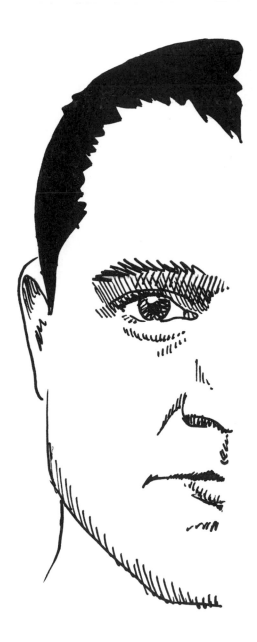

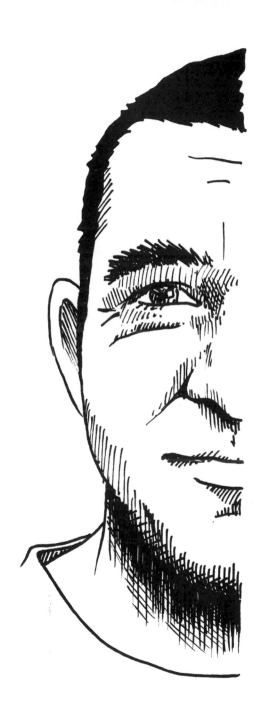

FURTHER PRACTICE

Draw a picture of a relative or close friend, based on a photo. Snap a photo of the image and text it to them. See if this results in a relationship-damaging feud.

EXTRA CREDIT

Try to draw a quick sketch of someone in public without looking creepy or getting arrested.

PROFILE

Now that you've mastered drawing faces from the front (don't worry if you haven't), it's time to look at them from the side. In some ways, the profile may be easier to draw than a straight-on portrait. You don't have to worry about symmetry. You have half as many eyes, ears, and nostrils to deal with. And the subject can look at something else besides you, which makes them less likely to see how bad the drawing is and punch you before it's done.

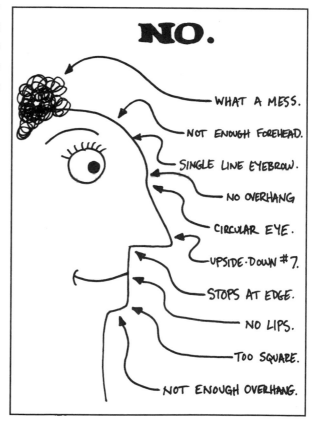

NO.

WHAT A MESS.

NOT ENOUGH FOREHEAD.

SINGLE LINE EYEBROW.

NO OVERHANG

CIRCULAR EYE.

UPSIDE-DOWN #7.

STOPS AT EDGE.

NO LIPS.

TOO SQUARE.

NOT ENOUGH OVERHANG.

YES.

HAIR CAN BE DRAWN SOLID.

TALL FOREHEAD.

EYEBROW IS FULL AND
 PROPERLY SHAPED.

EYE IS ARROW-SHAPED.

NOSE ISN'T AN
UPSIDE-DOWN #7.

CONTINUES INTO THE FACE.
DOESN'T END AT LIPS.

LIPS ARE NOT JUST A
SINGLE LINE. THEY ARE
FULL AND SHAPED PROPERLY.

CHIN IS NOT SQUARE.

LEAVE ROOM UNDER THE CHIN.

PRACTICE

You may want to do a few blind contour drawings of profiles before you get to the real drawings. I'll leave that up to you. Either way, start at the top of the head. If the subject has hair, draw it. If not, you may want to draw some anyway. It will make them look younger, and people always want to look younger. Then draw the forehead. If the subject has an enormous forehead, try not to laugh, gasp, or make jokes. Just draw it as you see it. Notice when you get to the eyebrows that they stick out, making an overhang to provide shade for the eyes. But there's usually a bit of a dent under the eyebrows and at the top of the nose. Make sure you get that part right. Then follow the line down the nose (again trying not to laugh) and really pay attention to the angle of the underside of the nose. Not every nose points straight out. Notice the depth of the overhang on the nose as well. When you are ready, draw the nostril (if you can see it), and move on to the upper lip. The upper lip usually curves outward, then inward toward the mouth. Does the upper lip stick out farther than the eyeballs? If you imagine a vertical line coming straight up from the upper lip, what does it run into? Look at your drawing and make sure it matches. Then draw the lower lip. Is it round or angular? Is there a curve that runs under the lower lip? How deep does it go? Now the chin. Does it stick out? How tall is it? When you draw the part under the chin, pay attention to how far the chin is from sthe neck. Now you can go back and draw the eye. Remember to draw the eye as you see it, not as you think an eye looks. Keep in mind, the same vertical proportions from the last section also apply to this one.

COPY THESE.

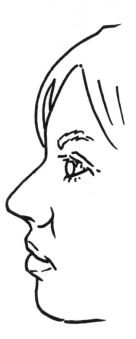

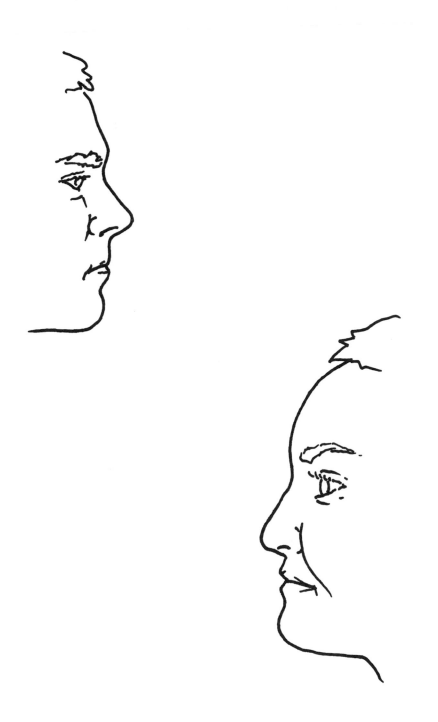

FINAL EXERCISE

Draw a celebrity mug shot. Or, if you have friends, you could draw them. Or if your friends are really interesting, draw their mug shots.

FURTHER PRACTICE

Draw profiles of your friends and family. Give them randomly as gifts. See if they realize they've gotten someone else's portrait.

EXTRA CREDIT

Cut a doorway in your home to the exact shape of your profile. Sure, you'll have to go through the door sideways from now on. But nobody else will be able to go in that room. Awesome!

PERSPECTIVE

One of the most effective ways to create the illusion of space in your drawings is with the use of linear perspective. We all know that distant objects appear smaller than they actually are. Linear perspective is the formula artists use to realistically render that concept.

Many early artists struggled with perspective, and some found varying degrees of success. But the true mathematical success is generally attributed to an Italian architect and goldsmith named Filippo Brunelleschi. In the early fifteenth century, he developed a simple method for drawing buildings and other objects as if they existed in three dimensions. Although his paintings of churches were more famous, his sketches of breakfast cereal boxes on supermarket shelves showed much more technical skill.

Not only did Brunelleschi perfect linear perspective, but he also designed and built the Cathedral of Saint Mary of the Flower (commonly referred to as "the Duomo") in Florence, Italy. It's the largest masonry dome ever constructed, and still stands six hundred years later.

One-point linear perspective is fairly simple. The artist establishes a horizon on the page. A single point on the horizon (a vanishing point) represents the artist's eye level. Any surface that is parallel to the artist's sight line can be drawn using lines that converge at the vanishing point. Any surface that is perpendicular to the sight line can be drawn using parallel lines (horizontal and vertical). Don't worry. It sounds more complicated than it is.

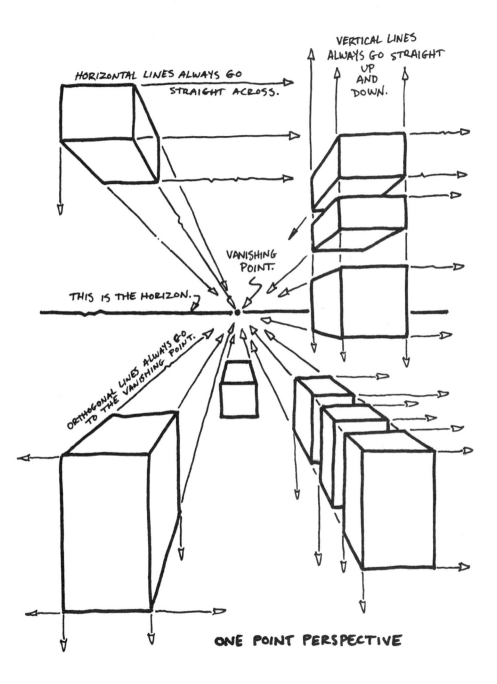

HORIZONTAL LINES ALWAYS GO STRAIGHT ACROSS.

VERTICAL LINES ALWAYS GO STRAIGHT UP AND DOWN.

VANISHING POINT.

THIS IS THE HORIZON.

ORTHOGONAL LINES ALWAYS GO TO THE VANISHING POINT.

ONE POINT PERSPECTIVE

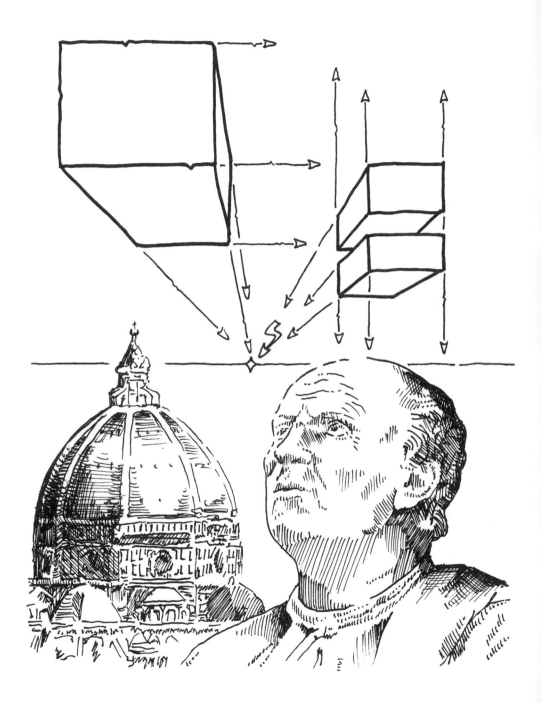

PRACTICE

Look at the room drawing. Notice the lines only go in three directions. Horizontal, vertical, or toward the vanishing point. Use highlighters or colored pencils to make all the horizontal lines yellow, all the vertical lines red, and all the lines that go to the vanishing point blue. Or pick your own colors. Just try to be consistent. You should be able to color every single line in the image. This should prove to you that there is a real formula to be followed, and if you trust the formula, your drawing will work.

Start by drawing simple shapes (cubes and boxes) using one-point perspective. Gradually make the shapes more complex as you gain skill and confidence.

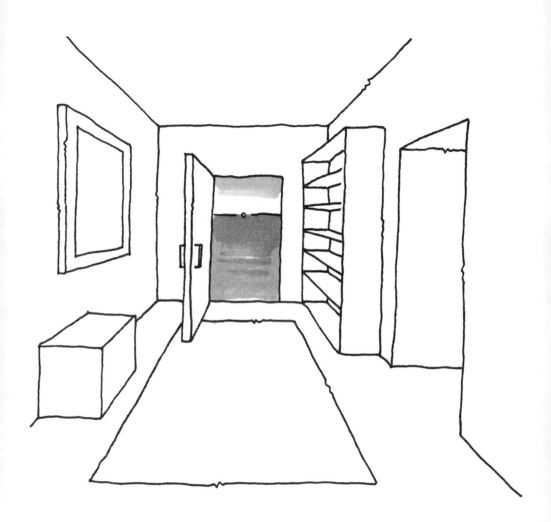

FINAL EXERCISE

Draw a room in your house. Try to include as much detail as possible, but don't get overwhelmed. You may need to oversimplify some of the pieces of furniture. You can also draw a box and fit the furniture within it. Keep in mind that if a piece of furniture is taller than you, the top will be invisible, in the same way the tops of tall buildings aren't seen from the street.

FURTHER PRACTICE

Pretend to be the reincarnated Brunelleschi, and draw the cereal aisle at the supermarket. Notice how the children's cereal is on the lower shelves, and the cereal for adults is stocked on the higher shelves. Ponder the mixed emotions felt by short adults or tall babies.

EXTRA CREDIT

Apply what you've learned to the outside world. Draw a street with some buildings, or the inside of a warehouse full of surplus smooth jazz records. Visit Florence and use your perspective skills to draw a street scene on the way to the Duomo.

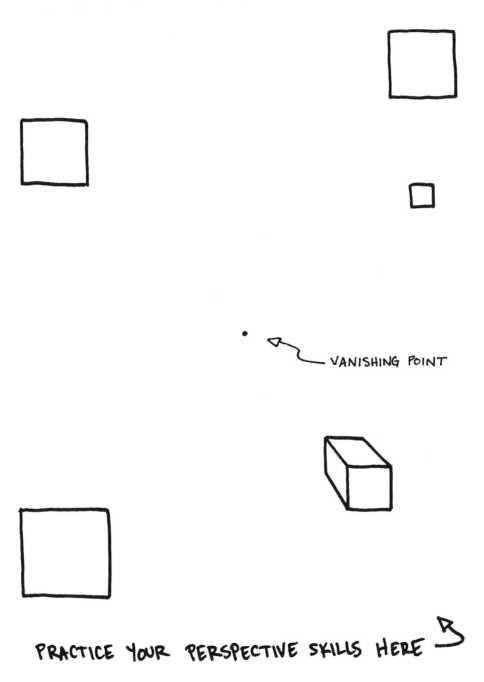

VANISHING POINT

PRACTICE YOUR PERSPECTIVE SKILLS HERE

STYLE

There comes a time when every artist must develop his or her own style. Anyone can be taught to reproduce line, color, value, space, texture, shape, and form. It takes a real artist to make these things interesting. The artist's unique touch is what makes an image worthy of the audience's attention.

Here, we'll look at a few artists who pioneered their own style, and take note of what makes each one so interesting.

PRACTICE

Study the artists listed here. Compare their portraits, and pay close attention to what makes each different. I drew each artist in some approximation of their own style, so you can see what made them stand out in their field. Spend some time practicing the different techniques in the portraits and figure out which ones you like and which ones you don't.

Vincent Willem van Gogh—You've probably already heard of van Gogh. Historians say the toxic chemicals in his paint made him unstable, so he cut off his own ear and gave it to a girl named Rachel (bad idea). He spent a lot of time painting cypress trees and wheat fields, so a lot of his drawings and paintings feature a rhythmic, swirling line work that pulses and undulates, and fills the most mundane areas with a delicious, feathery softness. Just look at those lines.

Henri Marie Raymond de Toulouse-Lautrec-Monfa (aka Toulouse-Lautrec)—For thousands of years, the acceptable subject matter for art was limited to religion, rich people, and nature. Toulouse-Lautrec made drawings of bartenders, drunks, and dancers. His drawings were beautiful in their spontaneity, honest in their simplicity, and they captured emotion and energy with swift scribbles and rapid hatching. He also carried a cane filled with liquor.

Georges Seurat—He is a very interesting case. Seurat reasoned that if yellow and blue make green, he should be able to put tiny dots of yellow in with tiny dots of blue, and when viewed from a distance, he would see green. Of course, he was right, and the result is called "pointillism." He spent two years (two years!) painting a ten-foot-wide canvas with tiny tiny tiny little dots of all kinds of colors. The result is an image of beautifully rounded forms and splendidly blended colors. People relax beside a body of water, and seemingly come together as fluidly as the paint dots, to create something more beautiful than the sum of their parts. His paintings ushered in a whole new major art movement.

Pablo Picasso—It's hard to pin Picasso down to just one style. He was a phenomenal draftsman and designer, he created a series of blue paintings that fill me with crippling despair, he helped invent collage, and he pioneered cubism. For this portrait, I decided to draw Picasso in a somewhat cubist fashion, where one can see multiple parts of the subject from different angles and vantage points, breaking free of the oppressive structure previously found in paintings. Also, it looks like the person is a mixed-up potato head, which is funny. Picasso was a true original, and he lived to a ripe old ninety-one. Go, Pablo!

FINAL EXERCISE

Pick an artist who created a self-portrait and spend some time analyzing his or her technique. Draw your own self-portrait in that artist's style. Look at a second artist, and replicate his style for your next self-portrait. Re-create a pop culture icon in the style of a completely unrelated artist or movement.

FURTHER PRACTICE

Find some other artists who came later and look for the influence of earlier artists in their pencil marks or brush strokes. Put together a style timeline, showing painting and drawing styles through the years. Figure out which era you like and why, and then practice that style.

EXTRA CREDIT

What's your style? How would you improve it? Why? You should find yourself balancing legibility, accuracy, and visual interest with ease of production. Is your style nearly impossible to achieve? Maybe it's time to simplify. If it's boring, spice it up. If it's jumbled, move toward clarity. Don't be afraid to continually try new techniques and styles. In the end, becoming a historically significant artist doesn't require that you be the best. You just have to do something new or exciting, engage the viewer, and get your art out into the world.

MAZE

Drawing a maze can help you improve your skills in several ways. You can work on spatial relationships, precision, attention to detail, and minimizing mistakes without using an eraser. You can use principles of design like unity, variety, balance, rhythm, and movement. A maze is a good way to practice line, and it activates a different part of your brain, so it's a good place to go when you're stuck on a more traditional drawing. Once you know how to make a good maze, you can use it to drive your friends crazy, or send cryptic messages to your local newspaper.

PRACTICE

Start on graph paper. Use a highlighter to draw a beginning and end point. Then draw a meandering path that connects them, using the squares on the graph paper as a guide. Give the solution a lot of turns, some long straight sections, and try to make it appear to go backward at least once. The more complex you make this solution, the more difficult the maze will be.

Then change to a new color of highlighter. Use this one to extend your solution into branches and dead ends. Every time your solution turns a corner, use the second color to add a branch that continues straight. If you have a long straight section in your solution, use the second color to branch off from that. Make sure these branches and

dead ends follow the squares on the graph paper, and make sure none of them touch, otherwise you may create a shortcut or a second solution. Some of your dead ends should be really long and complex, luring the victim into a false sense of security.

Use a third color to make a few fake branches that connect to the beginning, and a few that connect to the end. A lot of people like to "cheat" by starting at the end of the maze, so I like to treat the end the same as the beginning. Fill up all the remaining space, adding as many dead ends as possible.

Once the whole page is full, use a pen to draw all the walls in between the highlighted sections. Use the lines on the graph paper as a guide. This step is critical, because the exclusion of a single tiny line could ruin the entire maze. Other things that could ruin the maze: making it too easy, making it out of macaroni, sneezing on it.

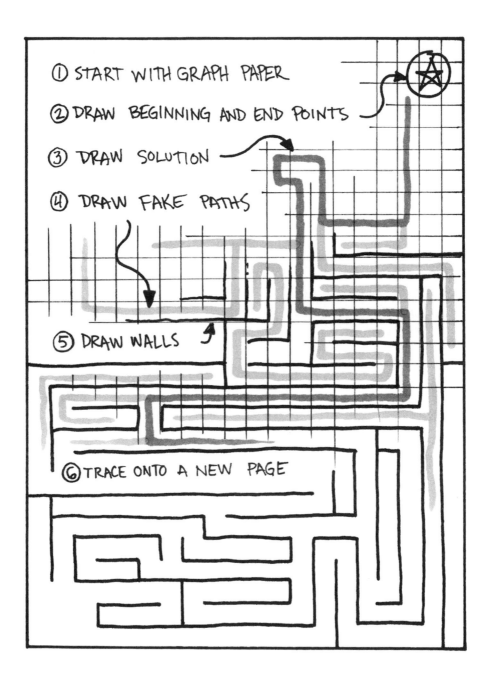

① START WITH GRAPH PAPER

② DRAW BEGINNING AND END POINTS

③ DRAW SOLUTION

④ DRAW FAKE PATHS

⑤ DRAW WALLS

⑥ TRACE ONTO A NEW PAGE

FINAL EXERCISE

Put a fresh sheet of white paper over the finished maze and carefully trace only the pen lines. This will give you a completed maze that can be copied and given to your friends. If you have trouble tracing the walls of the maze, use a light table, a window, or a glass table with a lamp underneath to shine light through the paper. There's no shame in tracing your own work.

FURTHER PRACTICE

Show your friends how to make a maze, and challenge them to see who can make the best one. Start an after-school (or after-work) maze club. Name it something like "ultra squad" because "maze club" sounds like a dork festival.

EXTRA CREDIT

Make a maze in which the solution draws a picture or spells out a word or phrase. Make a maze with a story or theme. Make a gigantic or tiny maze, or one that's extremely long and skinny.

MORE TO DRAW

Your drawing practice shouldn't stop when you finish these exercises. Regular, consistent, and rigorous practice is essential in order to improve your drawing skills, just as it is to cultivate and nurture any other ability.

Practicing drawing can be a terrifying experience. Once you have finished all the activities in this book, you may have difficulty deciding what to draw next. From time to time, you might struggle more with the idea than the execution. It's OK. Every artist (even the good ones) runs out of inspiration sometimes. Fortunately, you have me to help you.

This section contains several pages and activities designed to stimulate your "idea-brain" and help you come up with interesting things to draw. You should have fun working on these pages, but keep an open mind. You may get part of the way through one of them and suddenly have a vision of something completely different. Don't be afraid to run with it. Sometimes bad ideas are a gateway to good ones.

Starting with . . .

LETTERING STYLE

Lettering is another good way to express yourself artistically. Rather than simply writing something, you can draw the letters, and make it more exciting. In order to maximize your ability to draw beautiful letters, you should take some time to work on the entire alphabet, and explore a couple of different styles. Block letters are standard and legible. Bubble letters are soft and fun. The third set of letters should be wild and crazy.

BLOCK LETTERS:

START WITH A LETTER
THICKEN THE LINES
CAP THE ENDS
TRACE

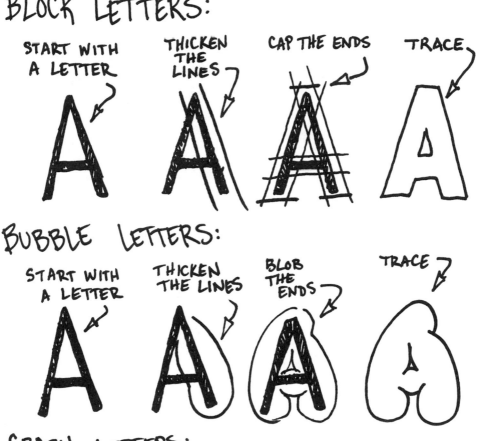

BUBBLE LETTERS:

START WITH A LETTER
THICKEN THE LINES
BLOB THE ENDS
TRACE

CRAZY LETTERS:

START WITH A BLOCK LETTER
LEAN IT
STRETCH IT
BREAK IT.

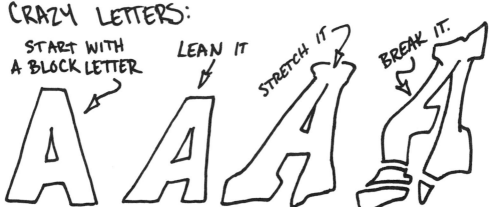

A B

DRAW A **BUBBLE LETTER ALPHABET**

A B C D E

F G H I J K

L M N O P

DRAW A CRAZY LETTER ALPHABET

LETTERING
LAYOUT

Proper placement of words on a surface hasn't changed much since the first Phoenician yard sale sign. Technically, they didn't have vowels, so it would have been more like a "YRD.SL." Either way, you should know how to put letters on something in a way that looks good. Use light guidelines to keep your letters consistent. Plan ahead. Maximize your space. Save the fancy stuff for last.

LETTERING LAYOUT

DON'T DO THIS!
YOU MUST PLAN AHEAD.

① START WITH LINES THAT SHOW THE OUTER EDGES OF THE LETTERS

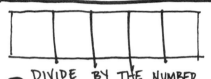

② DIVIDE BY THE NUMBER OF LETTERS. ALLOW FOR SKINNY LETTERS LIKE "I". INCLUDE SPACES/PUNCTUATION.

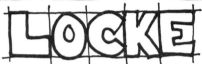

③ FILL EACH BOX WITH A LETTER. MAXIMIZE THE SPACE, SO THE LETTER TOUCHES ALL FOUR SIDES.

④ TRACE YOUR LETTERS ONTO A NEW SHEET OF PAPER.

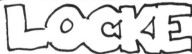

⑤ PICK A VANISHING POINT

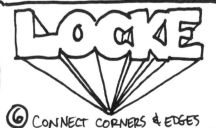

⑥ CONNECT CORNERS & EDGES TO THE VANISHING POINT.

⑦ ENJOY!

YOUR NAME HERE ⤴

DRAWING WITH YOUR EYES CLOSED

Now that you can draw in blind contour, and you can draw what you see, it's only natural that you should try drawing with your eyes closed. It's fun, it's silly, and it helps strengthen the connection between your brain and the pencil. If you enjoy this exercise, try getting your friends involved. You can take turns drawing the same thing, or you could try to guess what each other is drawing. It's fun for people of all ages!

DRAW WITH YOUR **EYES CLOSED.**
ABSOLUTELY NO CHEATIN'.

CARS

DRAW WITH YOUR EYES CLOSED.
FOR REAL.

HOUSES

FOOD

DRAW WITH YOUR EYES CLOSED!
SERIOUSLY. EYES CLOSED.

PEOPLE

WORLD'S WORST T-SHIRT

In 1626, Dutch settlers made a trade with a small tribe of Native Americans. The natives offered the entire state of New Jersey, and in exchange received three medium T-shirts, a bottle of Fanta, and a scratched-up copy of Michael Jackson's *Thriller*. The clever natives turned those T-shirts into a multimillion-dollar industry spanning eleven time zones. The Dutch settlers were eaten by wolves the following winter. Here's *your* chance to make T-shirt history. Design the world's worst T-shirt and start a new trend!

WORLD'S **WORST** T-SHIRT

#2

LONG FORMAT DRAWING

In order to create a nonstandard drawing, it may be necessary to use a nonstandard format. Here is one way to break yourself free from the world's rigid restraints. Draw some things that are ludicrously long or terrifically tall. I like to keep a roll of adding machine paper on hand for these drawings, but if you draw small enough, you can fit them in the margins of books. Either way, it's a good excuse to draw something totally crazy.

DRAWINGS DON'T HAVE TO BE
LIKE THIS ⌐▷ [] OR THIS ⌐▷ []

SOMETIMES THEY ARE LIKE THIS ↗

AND SOMETIMES LIKE THIS ↴

HERE'S YOUR CHANCE TO DO
SOME "LONG FORMAT" DRAWINGS.

A LANDSCAPE ↗

WAITING IN LINE ↗

WORLD'S LONGEST DOG ↗

UFO
SIGHTING

LONG FORMAT IDEAS:

- TARGET PRACTICE
- CITY SKYLINE
- SNAKES ON A DATE
- WHAT'S HE RUNNING FROM?
- TRAFFIC JAM
- A WACKY TRAIN
-
-
-
-
-

TALL FORMAT IDEAS:

- DIGGING A HOLE
- TALLEST BUILDING
- TALLEST PERSON
- OFF A CLIFF
- SOMETHING THAT FLIES
- WHAT'S IN THE WELL?
-
-
-
-
-

EXPANDING ON AN IMAGE

Start with a picture from a magazine or newspaper. Don't think too much about what you pick. Try to stick with something simple. Cut out a small square and glue it into the book. Then, fill in the rest of the page with a drawing that incorporates the original image. Try to make the transition as seamless as possible by matching the style, value, and color of the original photo. The finished drawing doesn't have to make sense. This is more about context and matching.

CUT A PICTURE
FROM A MAGAZINE.
GLUE IT HERE.
FILL THE REST
OF THE PAGE
WITH A DRAWING.

SELF-PORTRAIT AS A COMIC BOOK COVER

Imagine yourself as a comic book hero (or villain) and give yourself a name. Think of an exciting scene for your character to be involved in, and draw it as the cover of the comic book. Emphasize strong shadows, bold action, dynamic poses, and a limited selection of bright colors. Make it exciting, so other people would want to buy it and read it.

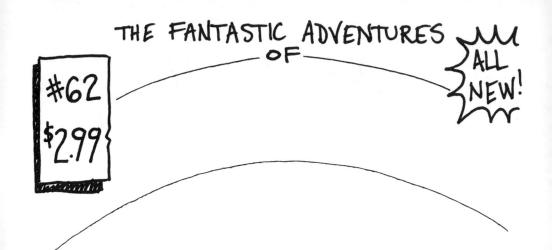

THE FANTASTIC ADVENTURES
OF

ALL NEW!

#62
$2.99

DRAW WHAT YOU SEE, THEN DRAW WHAT YOU DREW

This exercise will help you practice drawing what you see, instead of what you think should be there. Start by finding a house with interesting shapes, features, or architecture. You should spend only one minute drawing the house, so you will have to choose your lines, shapes, and shadows carefully. Draw as much of the house as you can in the sixty seconds. Then, while the drawing is still fresh, spend four minutes copying your drawing onto the next page as precisely as you can. Instead of drawing the house, now you are drawing the drawing of the house.

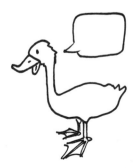

① FIND AN INTERESTING HOUSE. ② SET A TIMER FOR 60 SECONDS. ③ DRAW THE HOUSE.

① SET THE TIMER FOR 4 MINUTES.
② COPY THE HOUSE DRAWING.

DRAWING WHITE
ON BLACK

For these two pages, you'll have to think backward Instead of drawing shadows, this time you will draw highlights. Find a subject for the drawing and study it. What are the lightest parts? Draw those first, followed by the medium values. Leave the dark parts alone, as the paper is already black. This is a good way to force yourself to slow down and really be careful and purposeful with your value. Try to do these drawings without outlining anything in white. Be deliberate.

Use chalk, white pencil, crayon, gel pen, correction fluid, paint, metallic marker . . .

PRACTICE SPACE

PRACTICE SPACE

PRACTICE SPACE

ACKNOWLEDGMENTS

Thank you to my family, who encouraged me to keep drawing, even though I wasn't very good at it.

Thank you to my agent, Laurie Abkemeier, for holding my hand and guiding me through all of this. And to my editor, Marian Lizzi, who helped shape this collection of scribbles. Thanks to Lauren Appleton for working so hard on this project. Also, thank you to Bernadette Noll for introducing me to them!

I cannot express the depth of my gratitude to my wife, Liz Locke, and her superhuman endurance. You've always been there for me, like a cheerleader, an accountant, a maid, an editor, a publicist, and a critic. I wouldn't be where I am today if you weren't right here with me.

Finally, I would like to thank all the art teachers who have put up with my shenanigans and helped me learn and grow. Mr. Weinstein nurtured my childhood weirdness. Mr. Peters taught me not to be restricted by materials. Mrs. Casey has tolerated so much, and provided me the maximum freedom allowed by law. Mr. Naquin helped me explore digital art. Mrs. Dotterweich taught me perseverance. Mr. Wright told me I could make a living with art. Mrs. Yamaguchi showed me what it was like to commit to something larger than the present. And Mrs. Franson taught me how to teach art. I hope to honor all of you by teaching someone else some of what you all taught me. I wouldn't be an artist without you.

ABOUT THE AUTHOR

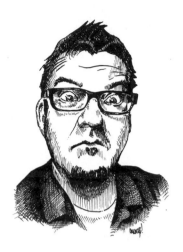

Christopher Locke was born a no-talent hack in a backwater suburb of Washington, D.C. Through hard work and dedication, he has conned his way into lots of books, magazines, galleries, and private collections. During the day, he teaches children how to draw. At night, he spends his time welding, sculpting in clay and concrete, and crushing his left thumb with heavy things. Anything worthwhile goes on his Web site, heartlessmachine.com, for ruthless ridicule by the general public.

He is also the author of *The Heartless Machine Guide to Drawing*, *99 Ways to Die: A Coloring Book for Adults*, *The Doodoo Book*, and *Sticky Note Portraits*.

He lives in Austin, Texas, with his wife, Liz, and their dog, Peaches.